S0-CFE-590

THE ART OF DRAWING
MANGA™

MONSTERS
& PETS

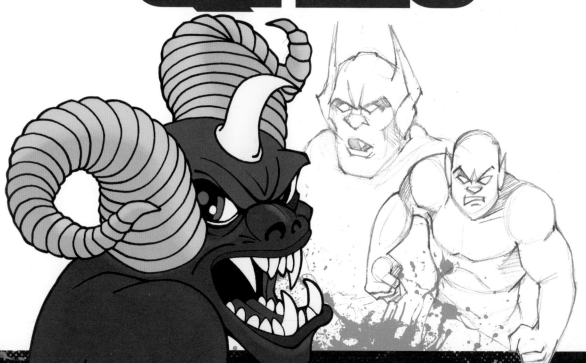

Author: Max Marlborough has been passionate about graphic design and manga from an early age and works as a freelance author, illustrator and designer of art guides for readers of all ages.

Artist: David Antram studied at Eastbourne College of Art and then worked in advertising for fifteen years before becoming a full-time artist. He has since illustrated many popular information books for children and young adults, including more than 60 titles in the bestselling *You Wouldn't Want To Be* series.

Additional artwork: Shutterstock

Published in Great Britain in MMXIX by
Book House, an imprint of
The Salariya Book Company Ltd
25 Marlborough Place, Brighton BN1 1UB
www.salariya.com

PB ISBN: 978-1-912537-59-4

SALARIYA
SCRIBO BOOK HOUSE SCRIBBLERS

© The Salariya Book Company Ltd MMXIX
All rights reserved. No part of this publication may be reproduced, stored in or introduced into a retrieval system or transmitted in any form, or by any means (electronic, mechanical, photocopying, recording or otherwise) without the written permission of the publisher. Any person who does any unauthorised act in relation to this publication may be liable to criminal prosecution and civil claims for damages.

1 3 5 7 9 8 6 4 2

A CIP catalogue record for this book is available from the British Library.

Printed and bound in China.

This book is sold subject to the conditions that it shall not, by way of trade or otherwise, be lent, resold, hired out, or otherwise circulated without the publisher's prior consent in any form or binding or cover other than that in which it is published and without similar condition being imposed on the subsequent purchaser.

Visit
www.salariya.com
for our online catalogue and
free fun stuff.

PAPER FROM
SUSTAINABLE
FORESTS

THE ART OF DRAWING
MANGA™

MONSTERS & PETS

BOOK HOUSE
a SALARIYA *imprint*

Contents

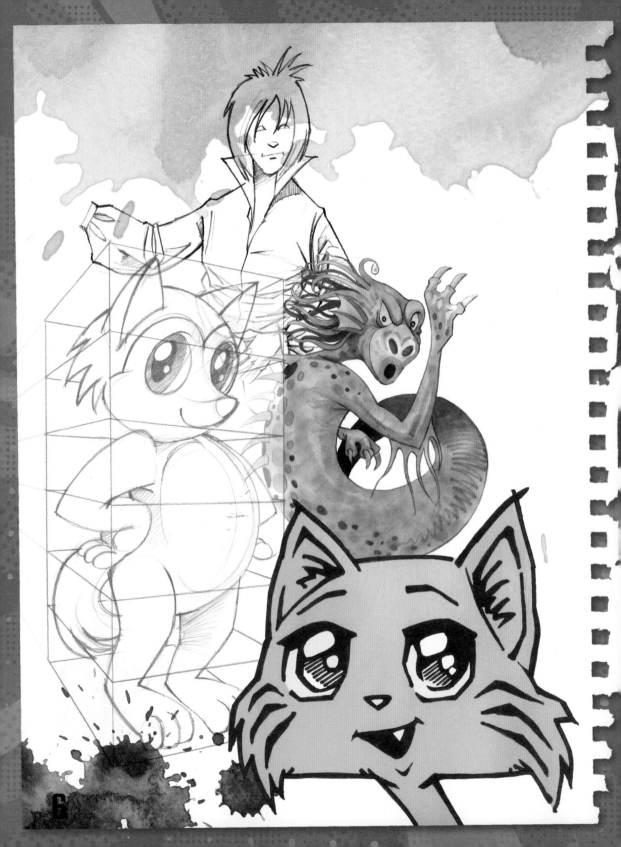

Making a start

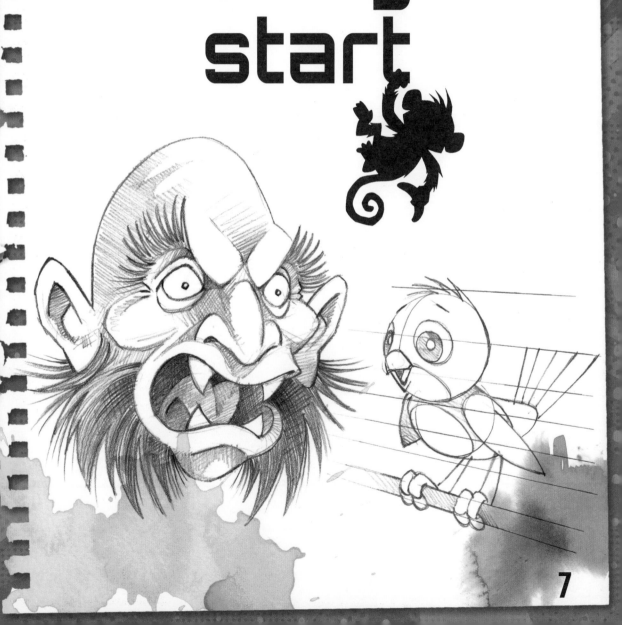

Introduction

The key to drawing well is learning to look carefully. Study your subject until you know it really well. Keep a sketchbook with you and draw whenever you get the chance. Even doodling is good – it helps to make your drawing more confident. You'll soon develop your own style of drawing, but this book will help you to find your way.

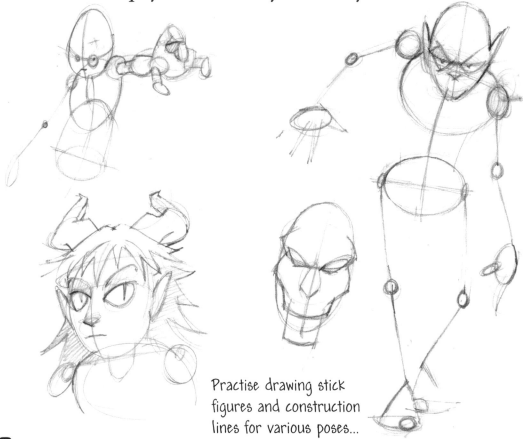

Practise drawing stick figures and construction lines for various poses...

Quick sketches

Try sketching your own pets (or friends' pets) in different positions.

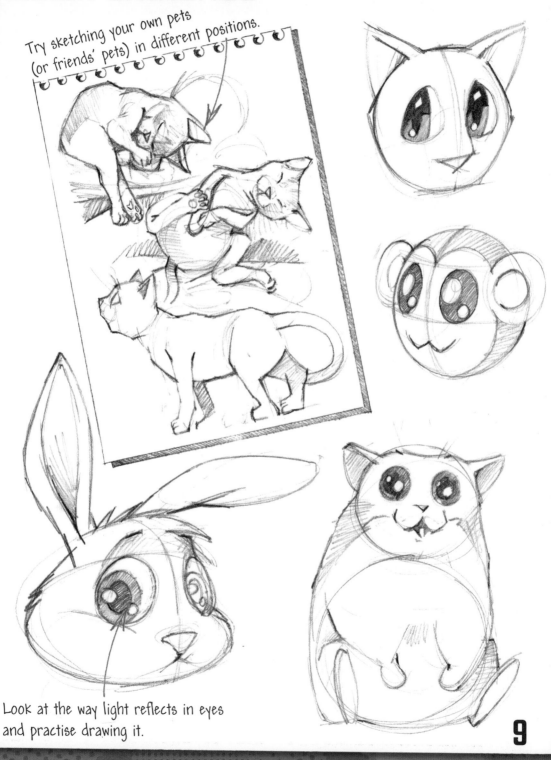

Look at the way light reflects in eyes and practise drawing it.

Introduction (2)

Practise drawing
basic head and
body shapes...

...then try adding
facial detail.

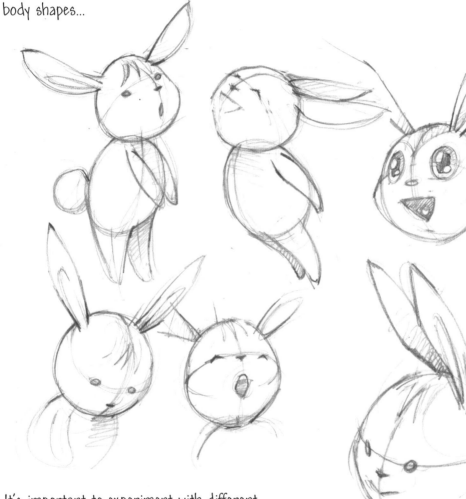

It's important to experiment with different
shapes and movements so that you gain
experience. Look at examples of manga to
see how other artists in the medium have
handled animal form.

More quick sketches

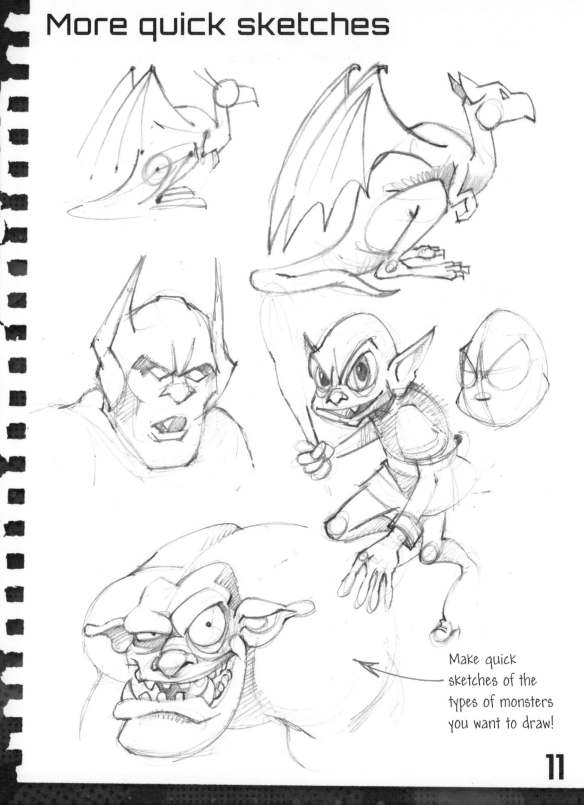

Make quick sketches of the types of monsters you want to draw!

Perspective

Perspective is a way of drawing objects so that they look as though they have three dimensions. Note how the part that is closest to you looks larger, and the part furthest away from you looks smaller. That's just how things look in real life.

The vanishing point (V.P.) is the place in a perspective drawing where parallel lines appear to meet. The position of the vanishing point depends on the viewer's eye level.

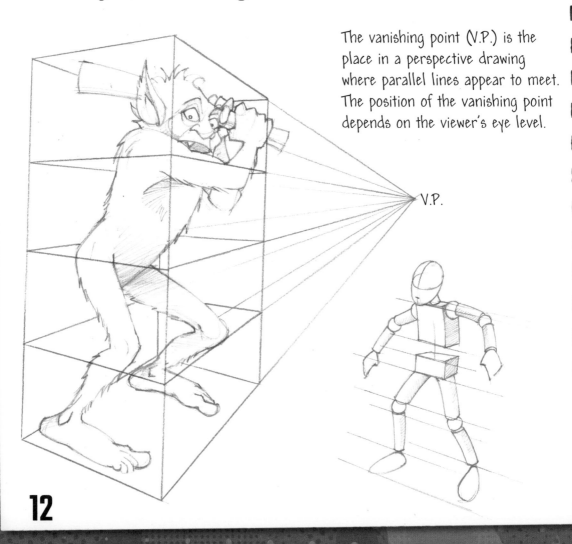

V.P.

Two-point perspective drawing

Two-point perspective uses two vanishing points: one for lines running along the length of the subject, and one on the opposite side for lines running across the width of the subject.

Low eye level
(view from below)

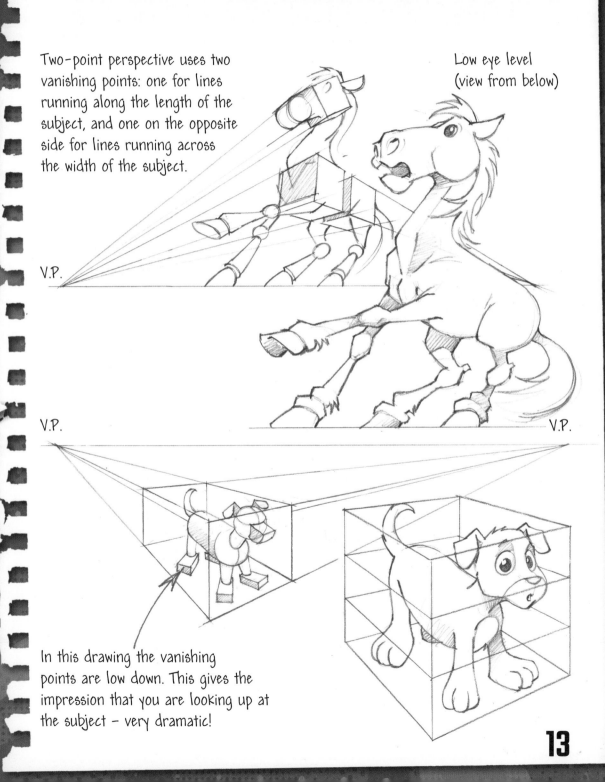

V.P.

V.P.

V.P.

In this drawing the vanishing points are low down. This gives the impression that you are looking up at the subject – very dramatic!

Materials

Pencils
Try out different grades of pencils. Hard pencils make fine grey lines and soft pencils make softer, darker marks.

Erasers
are useful for cleaning up drawings and removing construction lines.

Paper
Bristol paper is good for crayons, pastels and felt-tip pens. Watercolour paper is thicker; it is the best choice for water-based paints or inks.

Remember, the best equipment and materials will not necessarily make the best drawing – only practice will.

Use this sandpaper block if you want to shape your pencil to a really sharp point.

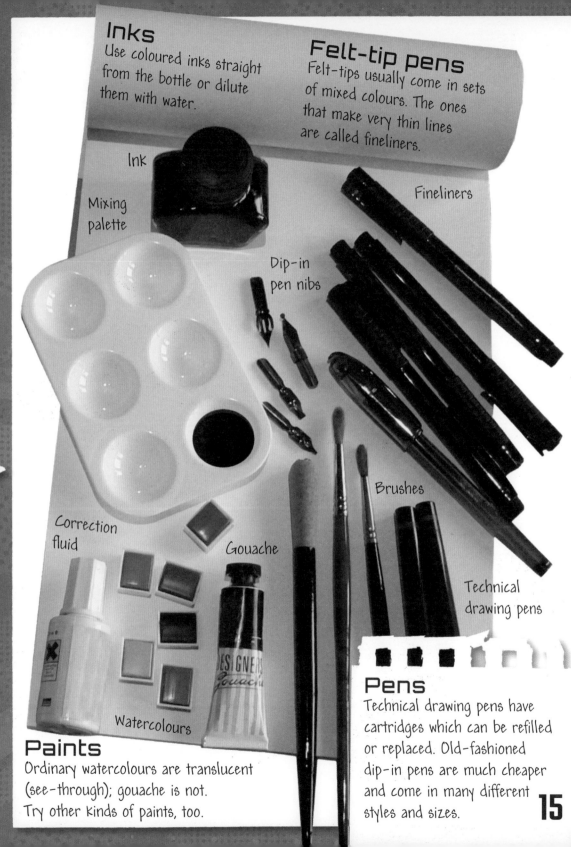

Inks
Use coloured inks straight from the bottle or dilute them with water.

Felt-tip pens
Felt-tips usually come in sets of mixed colours. The ones that make very thin lines are called fineliners.

Ink

Mixing palette

Fineliners

Dip-in pen nibs

Correction fluid

Gouache

Brushes

Technical drawing pens

Watercolours

Paints
Ordinary watercolours are translucent (see-through); gouache is not. Try other kinds of paints, too.

Pens
Technical drawing pens have cartridges which can be refilled or replaced. Old-fashioned dip-in pens are much cheaper and come in many different styles and sizes.

15

Styles

Try different types of drawing papers and materials. Experiment with pens, from felt-tips to ballpoints. They will make interesting marks. What happens if you draw with pen and ink on wet paper?

Ink silhouettes

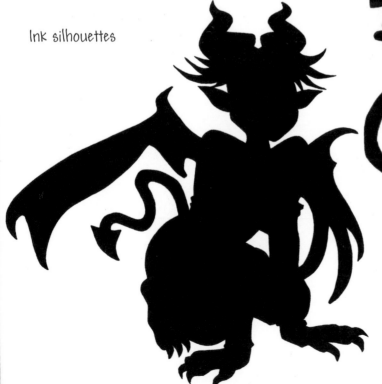

Silhouette is a style of drawing which mainly relies on solid dark shapes.

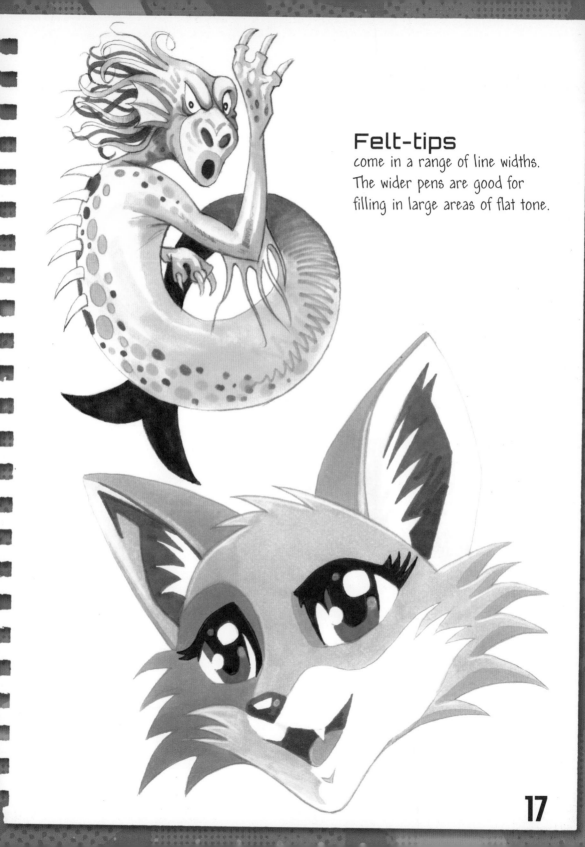

Felt-tips
come in a range of line widths.
The wider pens are good for
filling in large areas of flat tone.

17

Styles continued

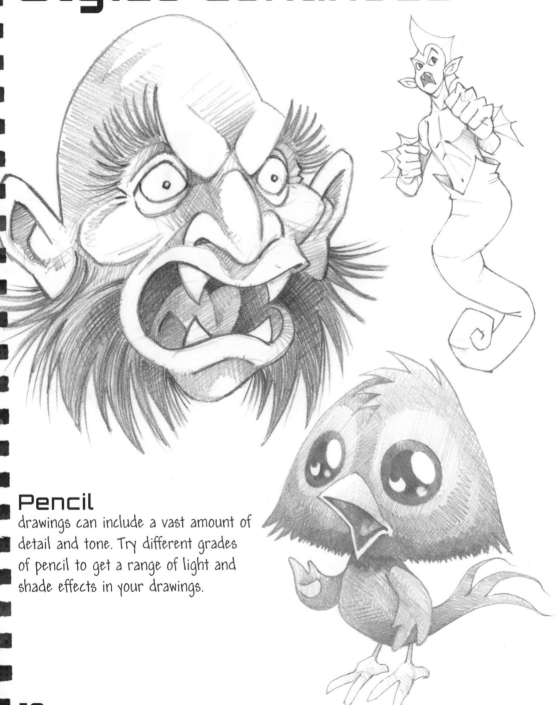

Pencil

drawings can include a vast amount of detail and tone. Try different grades of pencil to get a range of light and shade effects in your drawings.

Lines drawn in **ink** cannot be erased, so unless you are very confident you may want to sketch your drawing in pencil first.

It can be tricky adding light and shade to a drawing with a pen. Use a solid layer of ink for the very darkest areas and cross-hatching (straight lines criss-crossing each other) for ordinary dark tones. Use hatching (straight lines running parallel to each other) for midtones.

Hatching

Cross-hatching

Body proportions

Heads in manga are drawn slightly bigger than in real life. Legs and hips make up more than half the overall height of the figure.

Use boxes to proportion head and body size. For a four-legged creature like this, use two boxes.

The eye level is about midway down the head.

Use points to identify joints such as knees and elbows, so when you add detail to your character these will be in proportion.

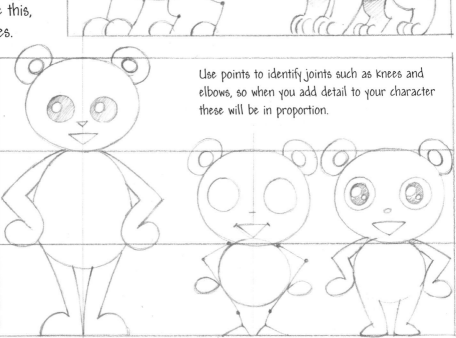

Drawing a stick figure is the simplest way to make decisions about a pose. It helps you see how different positions can change the centre of balance.

Draw simple lines for the limbs, spine and joints. Add ovals for the main sections of the body.

The eye level is about midway down the head.

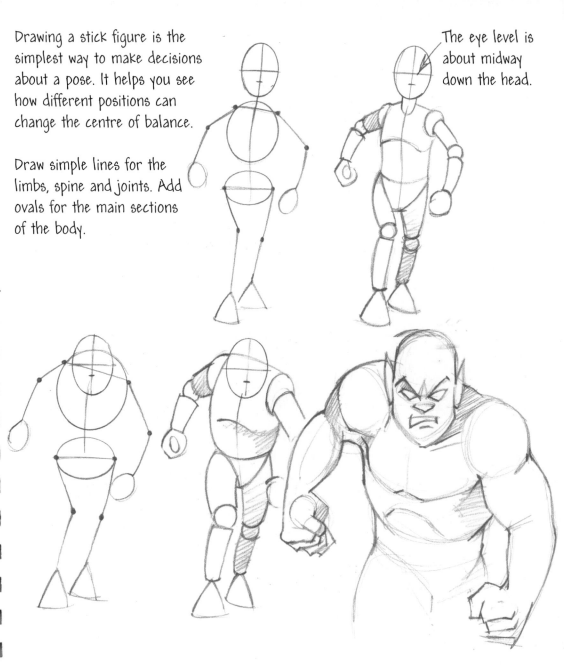

These three stages show how a body is developed from a stick figure.

With monsters, you can experiment with dramatic, threatening poses.

Inking

Here's one way of inking over your final pencil drawing. Different tones of ink can be used to add depth to the drawing. Mix ink with water to achieve the tones you need.

Refillable inking pens come in various tip sizes. The tip is what determines the width of the line that is drawn. Sizes include: 0.1, 0.5, 1.0, 2.0 mm.

Here's one way of inking over your final pencil drawing.

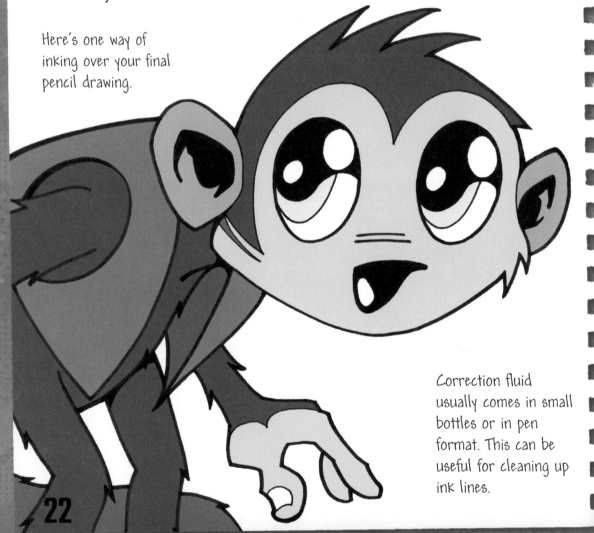

Correction fluid usually comes in small bottles or in pen format. This can be useful for cleaning up ink lines.

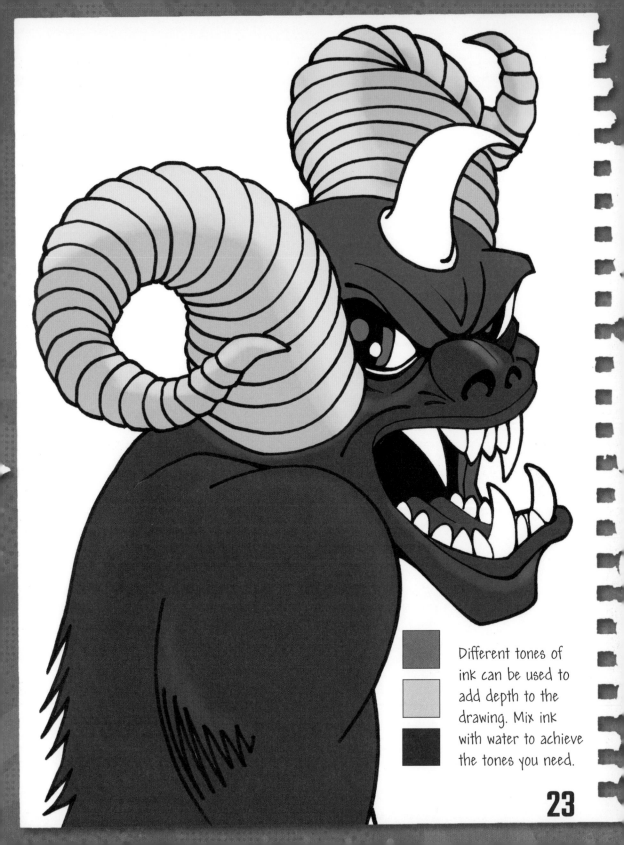

Different tones of ink can be used to add depth to the drawing. Mix ink with water to achieve the tones you need.

Heads

Manga heads have a distinctive style and shape. Manga monsters, specifically, may have exaggerated features such as noses, ears and teeth. Drawing different facial expressions is very important – it shows instantly what your character is thinking or feeling.

Start by drawing the head shape. Think wider oval shapes for cat's faces, circular shapes for mice and longer shapes for horses or squirrels.

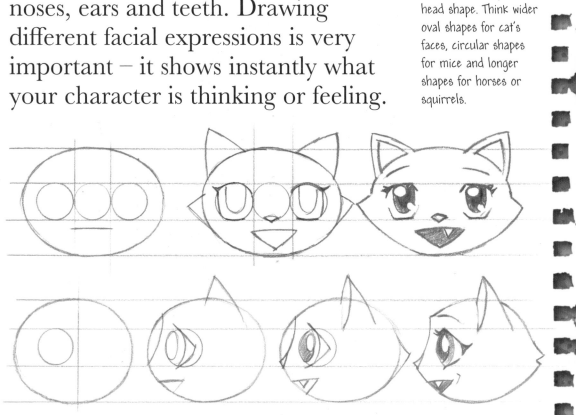

1. Draw vertical and horizontal construction lines. These will position the eyes.

2. Use the space created by the construction lines to centre the nose and mouth.

3. Add a pupil to the eye and draw in the nose, mouth and ears.

4. Add more detail such as eyes, eyebrows and teeth.

Practise drawing heads from different angles and with different facial expressions.

Whichever way the head is turned, the nose and mouth always stay on the centreline.

 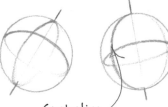

Centreline

Excited

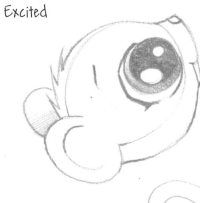

Frightened

Dreamy

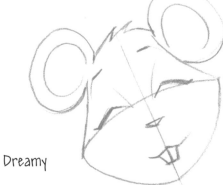

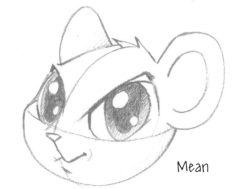

Mean

Happy

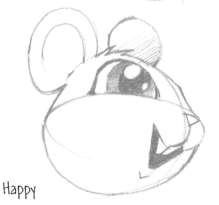

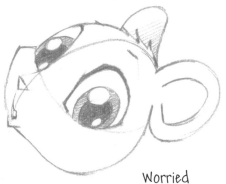

Worried

25

Heads continued

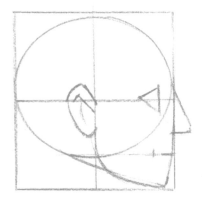

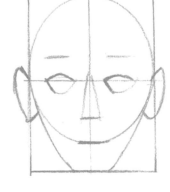

2. Draw construction lines to position the top of the ear and the base of the nose.

1. Start by drawing a square. Fit the head, chin and ears inside it to keep the correct proportions.

Practise drawing heads from different angles...

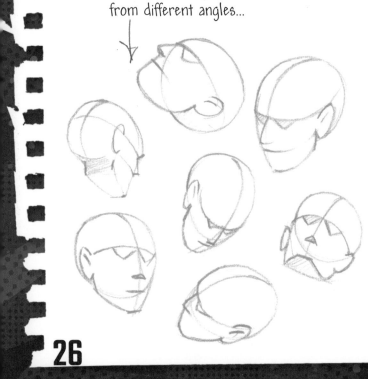

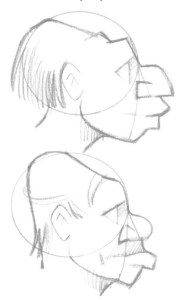

Drawing a profile view means you can have more fun with monster head shapes, noses, mouths, ears and hair!

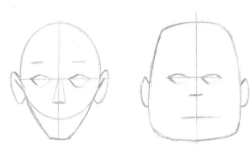 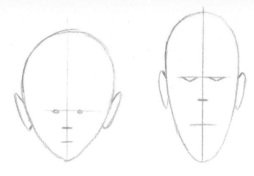

Monsters can have all sorts of weird and wonderful heads. See what strange heads you can imagine.

These four construction line head shapes are the basis for the finished heads below.

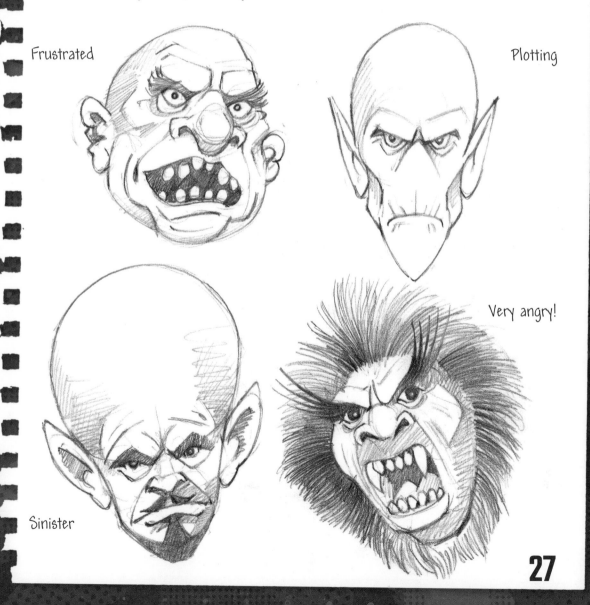

Frustrated

Plotting

Sinister

Very angry!

Creases and folds

Clothes fall into natural creases and folds when worn. Look at real people to see how fabric drapes and how it falls into creases. This will help you to dress your characters more realistically.

The way fabric hangs depends on the type and weight of the material.

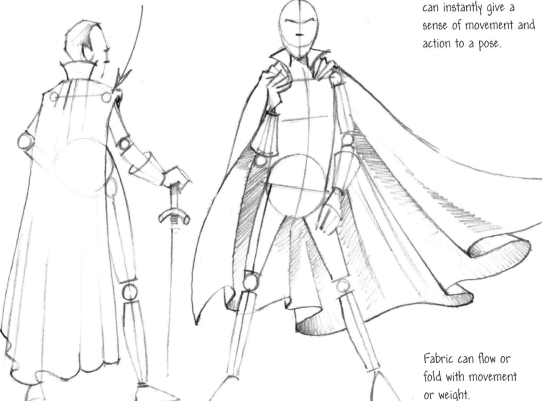

The way fabric is drawn can instantly give a sense of movement and action to a pose.

Fabric can flow or fold with movement or weight.

Chibifying

Chibi is a manga style where the subject is small and cute. Any drawing can be made into chibi style by exaggerating features while keeping the body small.

Your manga pets can come in all shapes and sizes. You can change the construction circles and lines depending on the type of animal, or what kind of character you want it to be.

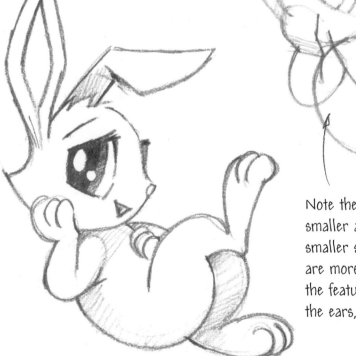

Note the construction circles are smaller and rounder, producing a smaller shape, the facial features are more cartoonish and some of the features are enlarged, such as the ears, eyes and feet.

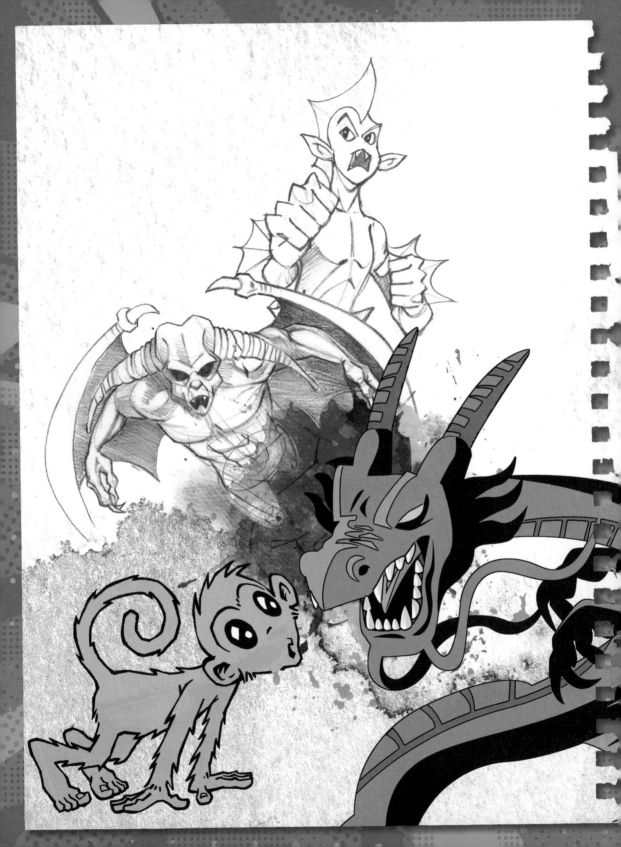

Characters

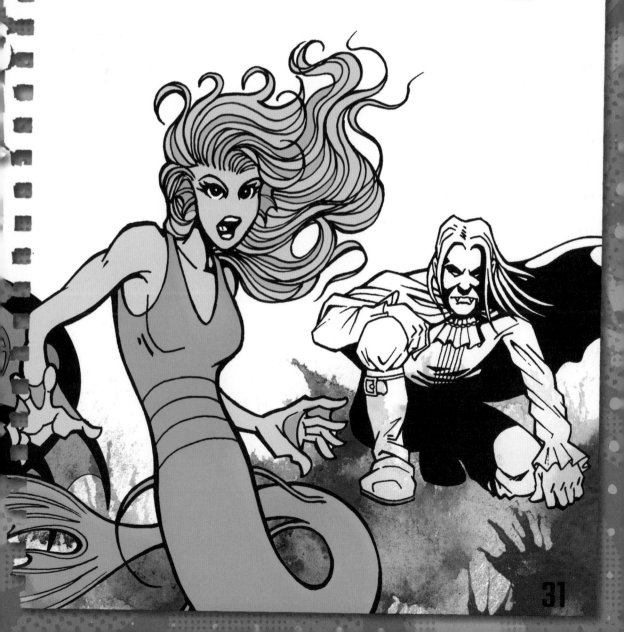

Akemi

This boy is having fun, circled by his winged pet Akemi who protects him at all times.

These little circles are to remind you where the elbows and knees go.

1. Draw ovals for the head, body and hips. Add centre lines to divide the head vertically and horizontally. These will help you to place the ears and the nose.

2. Add lines for the spine and the angle of the hips and shoulders.

Cat's ears

3. Draw stick arms and legs, with dots where the joints are. Add outline shapes for hands and feet.

4. Sketch the cat in the same way – add a spiky effect to create a bushy tail.

5. Using the construction lines as a guide, start to build up the main shapes and features.

6. Draw the clothes, hair and facial features. This is where your drawing really starts to come to life.

Drawing movement lines (in this case, swimming) creates the impression of speed.

Why not add a catlike sound effect?

Try a feathered wing effect. Forward-pointing paws create a streamlined image.

Shadow

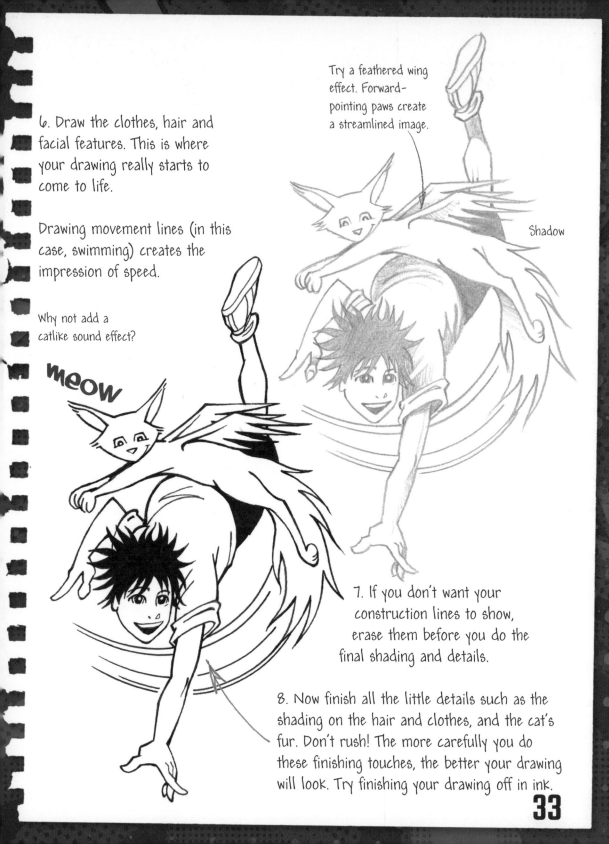

meow

7. If you don't want your construction lines to show, erase them before you do the final shading and details.

8. Now finish all the little details such as the shading on the hair and clothes, and the cat's fur. Don't rush! The more carefully you do these finishing touches, the better your drawing will look. Try finishing your drawing off in ink.

Night hunter

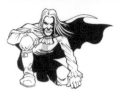

The night hunter is a vampire. He is moody, and very dangerous to cross. Beware of dark shadows where you won't see him coming!

1. Draw ovals for the head, body and hips. Add centre lines to divide the head vertically and horizontally. These will help you to place the ears and the nose.

2. Add lines for the spine and the angle of the hips and shoulders.

3. Draw stick arms and legs, with dots where the joints are. Add outline shapes for hands and feet.

These little circles are to remind you where the elbows and knees go.

A flowing cape gives the character a dramatic edge.

4. Using the construction lines as a guide, start to build up the main shapes and features.

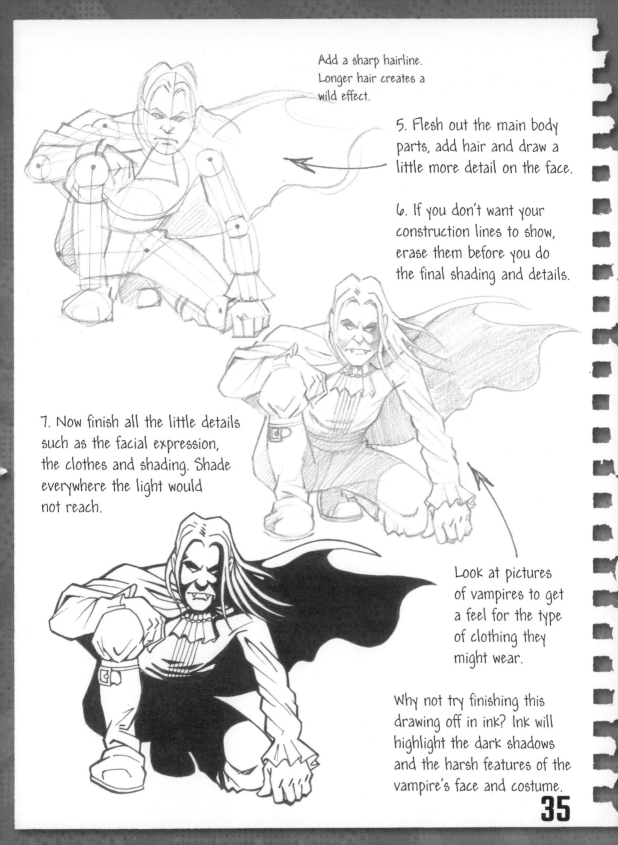

Add a sharp hairline.
Longer hair creates a
wild effect.

5. Flesh out the main body
parts, add hair and draw a
little more detail on the face.

6. If you don't want your
construction lines to show,
erase them before you do
the final shading and details.

7. Now finish all the little details
such as the facial expression,
the clothes and shading. Shade
everywhere the light would
not reach.

Look at pictures
of vampires to get
a feel for the type
of clothing they
might wear.

Why not try finishing this
drawing off in ink? Ink will
highlight the dark shadows
and the harsh features of the
vampire's face and costume.

Kazuki dog

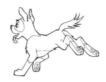

Kazuki is very loyal, full of energy and always wanting to play. Draw him running as he's always in action!

1. Draw a circle for the head and ovals for the body and hips.

2. Add lines for the spine and the angle of the hips and shoulders.

3. Draw stick arms and legs with dots for the joints.

Think about the angle of a dog's legs – when they are running fast, they bend at a sharp angle and bring their back legs up high.

Small circles indicate the positions of elbows and knees.

4. Use your guidelines to sketch in the neck and facial features.

5. Using the construction lines as a guide, start drawing in the main shapes of the body.

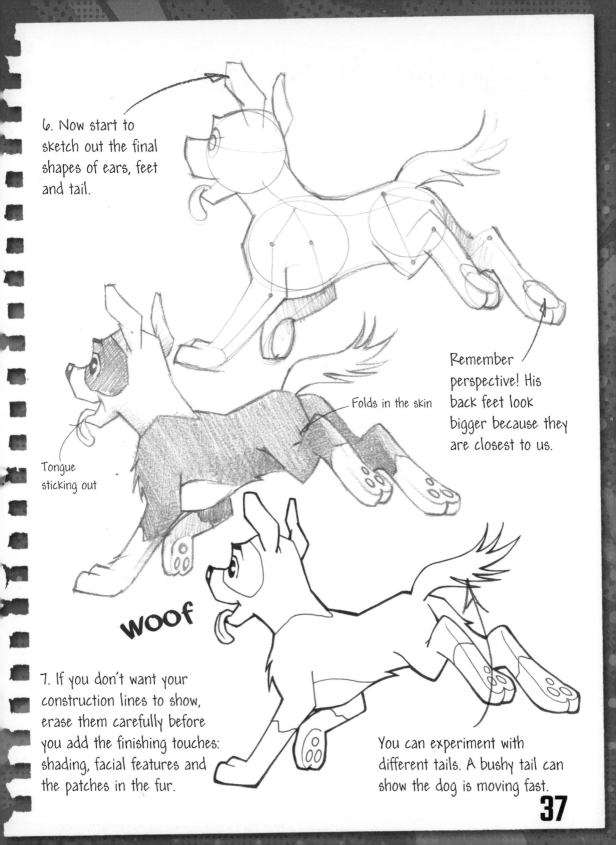

6. Now start to sketch out the final shapes of ears, feet and tail.

Remember perspective! His back feet look bigger because they are closest to us.

Folds in the skin

Tongue sticking out

WOOF

7. If you don't want your construction lines to show, erase them carefully before you add the finishing touches: shading, facial features and the patches in the fur.

You can experiment with different tails. A bushy tail can show the dog is moving fast.

37

Akuma

Akuma is Japanese for 'devil', a demon who haunts dreams. If a person is bad, the akuma poses riddles to decide his or her fate.

1. Draw different-sized ovals for the head, body and hips.

2. Add a line for the spine and others to show the angle of the hips and shoulders.

Have fun with the head shape.

Sharp claws

Circles with dots show the position of the joints.

3. Draw stick arms and legs with dots for the joints and outline shapes for the hands. Above the arms, draw an outline of the wings.

4. Using your construction lines as a guide, draw the main shapes of the body and the position of the facial features.

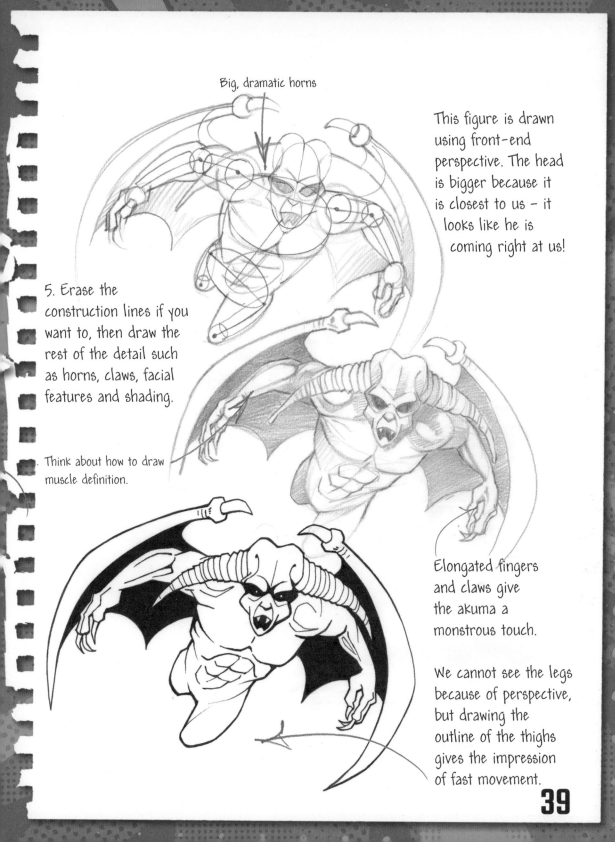

Big, dramatic horns

This figure is drawn using front-end perspective. The head is bigger because it is closest to us – it looks like he is coming right at us!

5. Erase the construction lines if you want to, then draw the rest of the detail such as horns, claws, facial features and shading.

Think about how to draw muscle definition.

Elongated fingers and claws give the akuma a monstrous touch.

We cannot see the legs because of perspective, but drawing the outline of the thighs gives the impression of fast movement.

Satsuki

Satsuki is sassy, sly and always around when something goes wrong, but she gets away with it for being so adorable.

1. Draw circles for the head and the body – don't forget your centre line.

2. Add a line for the spine and half-circles on either side for the legs.

3. Draw stick arms and circles for hands.

4. Using your construction lines, add the shape of the head, legs, feet and paws.

Add the shape of the tail.

5. Flesh out the arms and legs, adding details to the ears and tail. Try some basic facial features.

Practise sassy facial expressions

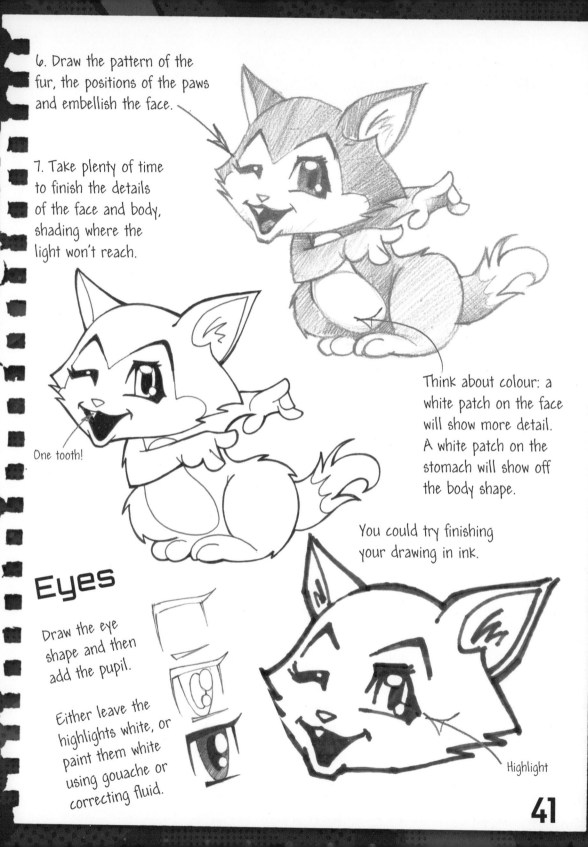

6. Draw the pattern of the fur, the positions of the paws and embellish the face.

7. Take plenty of time to finish the details of the face and body, shading where the light won't reach.

One tooth!

Think about colour: a white patch on the face will show more detail. A white patch on the stomach will show off the body shape.

You could try finishing your drawing in ink.

Eyes

Draw the eye shape and then add the pupil.

Either leave the highlights white, or paint them white using gouache or correcting fluid.

Highlight

41

Witch

The witch is very old and can see into the future. She can tell you your fortune but always at a price. She doesn't like children.

1. Draw a circle for the head and ovals for the body and hips.

2. Add lines for the spine and the angle of the hips and shoulders.

4. Use your guidelines to sketch in the neck and facial features.

3. Draw stick arms and legs with dots for the joints.

Small circles indicate the positions of elbows and knees.

5. Using the construction lines as a guide, start drawing in the main shapes of the body. Pencil in details such as the cape and walking stick.

6. Now start to sketch out the final shapes of clothes, hair, arms and legs. Think about what kind of facial expression the witch would have.

7. If you don't want your construction lines to show, erase them carefully before you add the finishing touches: shading, facial features, folds and creases on the clothes.

Draw in the shape of the fingers.

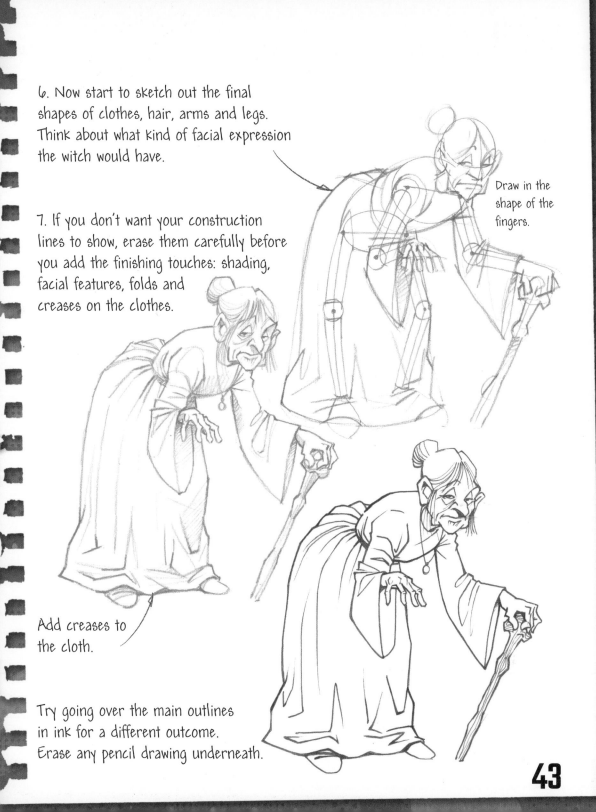

Add creases to the cloth.

Try going over the main outlines in ink for a different outcome. Erase any pencil drawing underneath.

43

Maru monkey

Maru is a very curious creature and loves being around people. He enjoys exploring and discovering new things.

1. Draw different-sized ovals for the head, body and hips. Add a line for the spine and others to show the angle of the hips and shoulders.

2. Draw stick arms and legs with dots for the joints and outline shapes for the hands and feet. Draw a line for the position of the tail.

Ears are positioned with the centre line in the middle.

Circles show positions of elbows and knees.

3. Using your construction lines as a guide, draw the main shapes of the body and position the facial features.

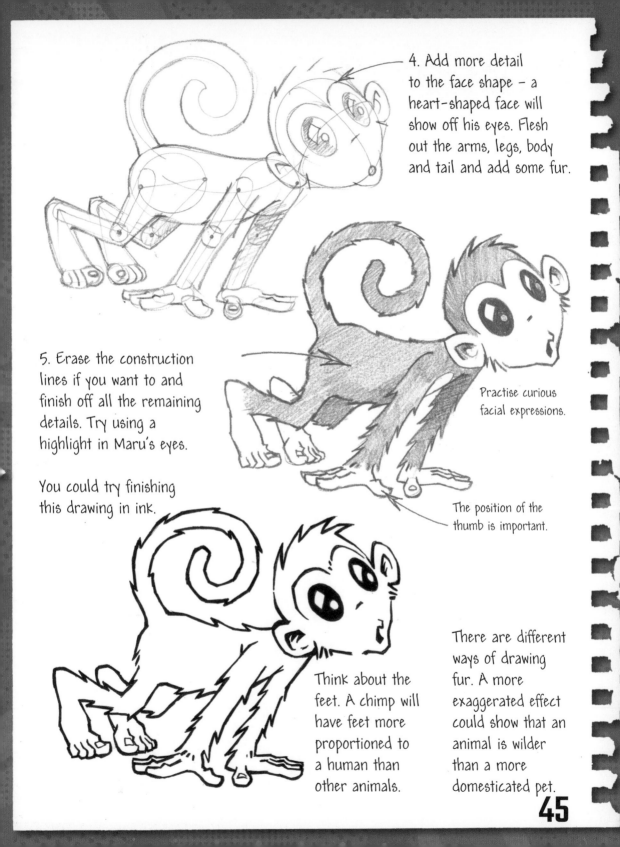

4. Add more detail to the face shape – a heart-shaped face will show off his eyes. Flesh out the arms, legs, body and tail and add some fur.

5. Erase the construction lines if you want to and finish off all the remaining details. Try using a highlight in Maru's eyes.

You could try finishing this drawing in ink.

Practise curious facial expressions.

The position of the thumb is important.

Think about the feet. A chimp will have feet more proportioned to a human than other animals.

There are different ways of drawing fur. A more exaggerated effect could show that an animal is wilder than a more domesticated pet.

Dragon slayer

The dragon slayer is a fierce and ferocious knight. He'll stop at nothing on his quest to fight and kill every dragon in the land.

1. Draw ovals for the head and hips and a circle for the body.

2. Add lines for the spine and the angle of the hips and shoulders.

3. Add a line for the sword.

4. Draw stick arms and legs with dots for the joints.

5. Using your construction lines, add the neck and sketch in the facial features.

Draw two circles and a construction line for the dragon's head, too. Add more detail as you go along.

6. Flesh out the arms and legs, using circles to indicate elbows and knees.

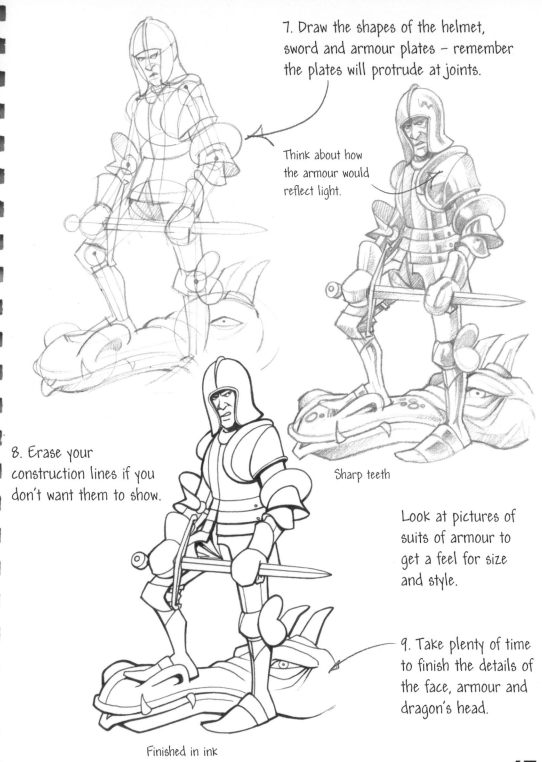

7. Draw the shapes of the helmet, sword and armour plates – remember the plates will protrude at joints.

Think about how the armour would reflect light.

8. Erase your construction lines if you don't want them to show.

Sharp teeth

Look at pictures of suits of armour to get a feel for size and style.

9. Take plenty of time to finish the details of the face, armour and dragon's head.

Finished in ink

Daiki donkey

This donkey can always be relied upon to make a lot of noise. He can't be trusted with any secrets!

Eyes and ears always go on the centre line. Sketch an open mouth shape and use this to connect the two head circles.

1. Draw different-sized circles for the hips, body and mouth. This time we need a second smaller circle for the donkey's elongated head shape.

2. Draw in a curved line connecting the circles, for the spine and neck.

3. Draw stick legs with dots for the joints. The back legs should be open.

Circles show positions of the joints.

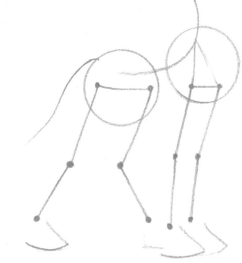

4. Using your construction lines, sketch in the basic shapes of the head, body, legs and tail.

Think about the feet – hooves are triangular-shaped.

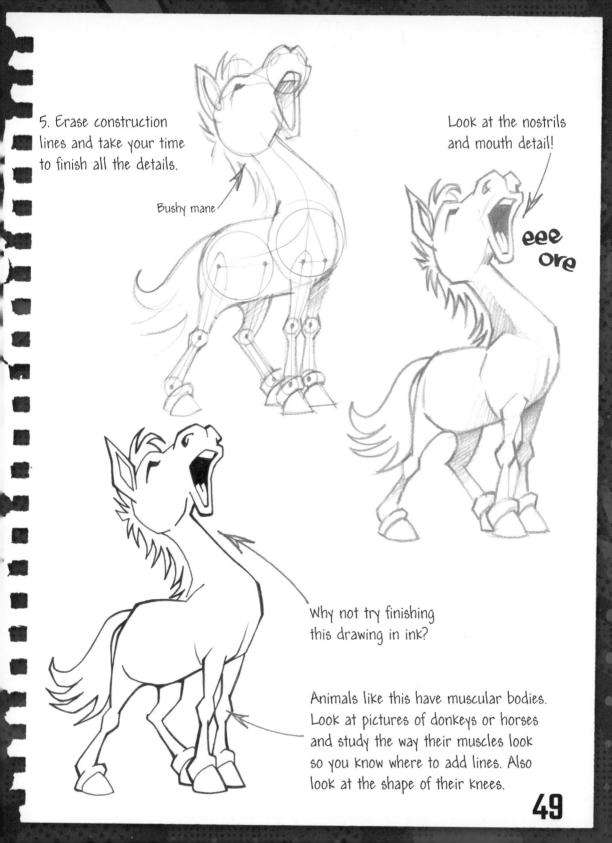

5. Erase construction lines and take your time to finish all the details.

Bushy mane

Look at the nostrils and mouth detail!

eee ore

Why not try finishing this drawing in ink?

Animals like this have muscular bodies. Look at pictures of donkeys or horses and study the way their muscles look so you know where to add lines. Also look at the shape of their knees.

49

Kappa

The kappa is a water demon. He is hundreds of years old, and he kills fish and other sea creatures. He is sly, and it is considered bad luck if you see him.

1. As you've done before, draw ovals for the head and body and a big circle for the hips, as the kappa is quite a round creature.

2. Draw construction lines for the spine and the angle of the hips and shoulders.

3. Draw stick arms and legs, with dots for the joints.

Add the hat shape.

Webbed hands and feet!

4. Using construction lines, flesh out the main parts of the body and face. Draw the basic shapes of the fish's head and tail.

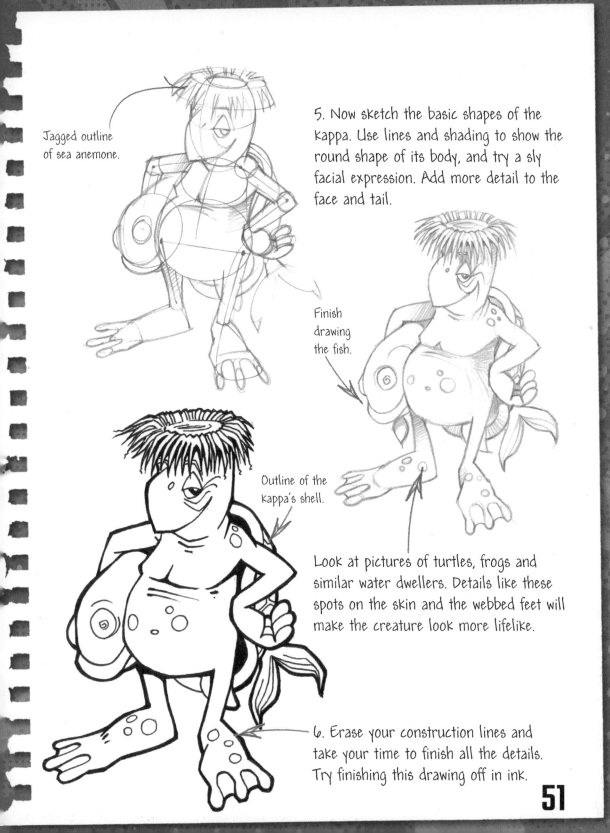

Jagged outline of sea anemone.

5. Now sketch the basic shapes of the kappa. Use lines and shading to show the round shape of its body, and try a sly facial expression. Add more detail to the face and tail.

Finish drawing the fish.

Outline of the kappa's shell.

Look at pictures of turtles, frogs and similar water dwellers. Details like these spots on the skin and the webbed feet will make the creature look more lifelike.

6. Erase your construction lines and take your time to finish all the details. Try finishing this drawing off in ink.

51

Kenzo frog

Kenzo is not the sharpest tool in the shed, but he has good intentions and makes everyone around him laugh.

Remember to draw where joints should be.

1. Draw the various ovals and construction lines. This time we need two overlapping circles sitting on the centre line for the eyes.

Long fingers

A triangle at the base of the head makes the bottom part of the mouth.

2. Add the limbs, feet and hands. Create an open mouth shape by drawing a curved line from the centre line of the head, and another from the centre line of the closest eye. Connect them.

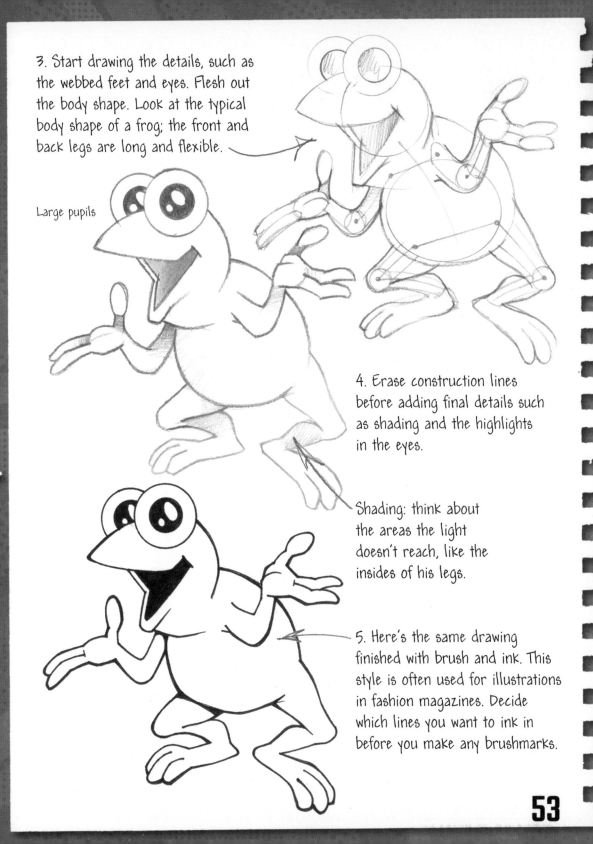

3. Start drawing the details, such as the webbed feet and eyes. Flesh out the body shape. Look at the typical body shape of a frog; the front and back legs are long and flexible.

Large pupils

4. Erase construction lines before adding final details such as shading and the highlights in the eyes.

Shading: think about the areas the light doesn't reach, like the insides of his legs.

5. Here's the same drawing finished with brush and ink. This style is often used for illustrations in fashion magazines. Decide which lines you want to ink in before you make any brushmarks.

Ningyo

The ningyo is a very beautiful mermaid, but also very dangerous. She rules the sea and lures sailors to their death.

I. Draw the various ovals and construction lines as you have done before. This time, instead of stick legs, draw a basic line and fish tail shape.

Don't forget the webbed hands!

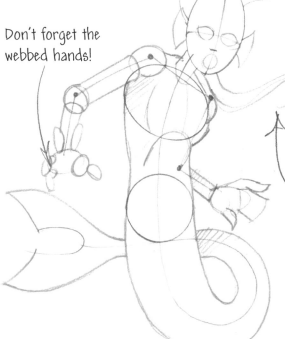

2. Using your construction lines, add the basic shapes of the torso, arms and tail. Sketch in the facial features.

Start drawing wisps of hair and build this up gradually to get a swept mane effect.

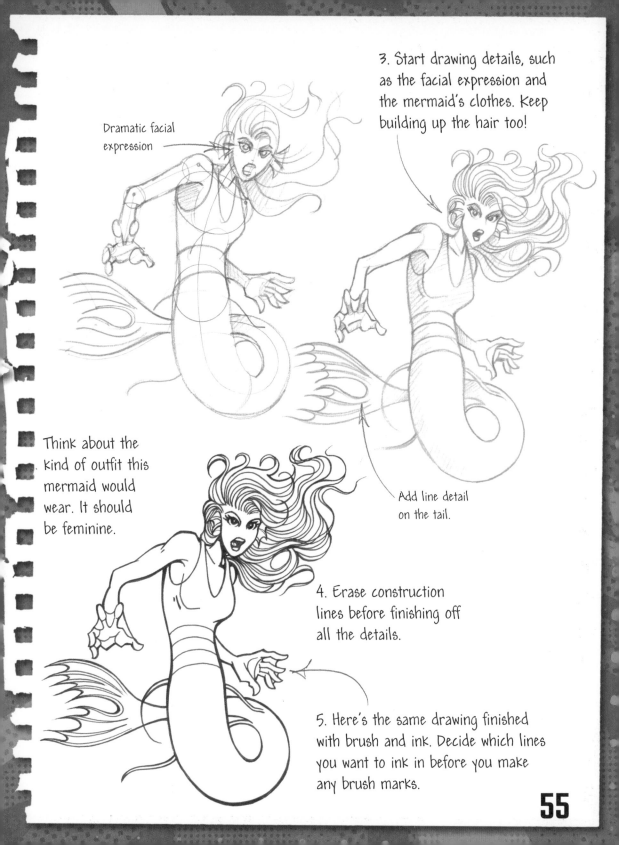

Dramatic facial expression

3. Start drawing details, such as the facial expression and the mermaid's clothes. Keep building up the hair too!

Think about the kind of outfit this mermaid would wear. It should be feminine.

Add line detail on the tail.

4. Erase construction lines before finishing off all the details.

5. Here's the same drawing finished with brush and ink. Decide which lines you want to ink in before you make any brush marks.

Miu

Miu is a good luck charm. Her owner keeps her on his shoulder, and Miu protects him from harm.

1. Draw the basic ovals and construction lines. The hamster's body shape is very round, so draw circles for the legs too.

2. Use your construction lines to add facial features and ears. Draw the arms as large folds, with long flat paws and feet.

Try sketching from a different angle:

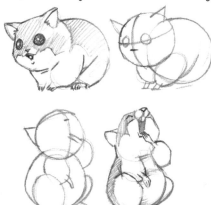

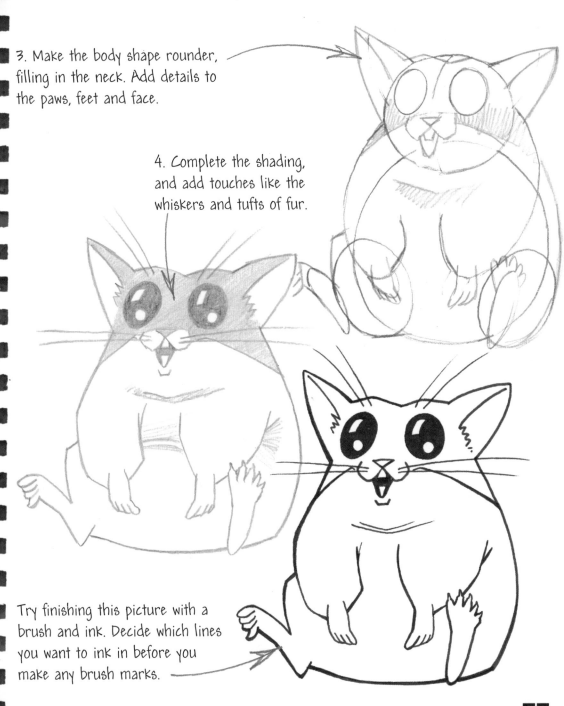

3. Make the body shape rounder, filling in the neck. Add details to the paws, feet and face.

4. Complete the shading, and add touches like the whiskers and tufts of fur.

Try finishing this picture with a brush and ink. Decide which lines you want to ink in before you make any brush marks.

Warrior girl

The warrior girl is warlike and ruthless. She protects her village fearlessly, and any trespassers fall victim to her wrath.

1. Draw the basic ovals and construction lines as usual. Remember the lines for the spine and hips. Draw stick arms and legs with dots for the joints. Draw a line for the sceptre too.

2. Sketch the arms and legs and the main facial features. Think about the pose of the warrior girl – she is putting her weight on her right leg, so her body is leaning slightly left.

Circles represent the joints.

Practise drawing clenched hands to get an idea of grip.

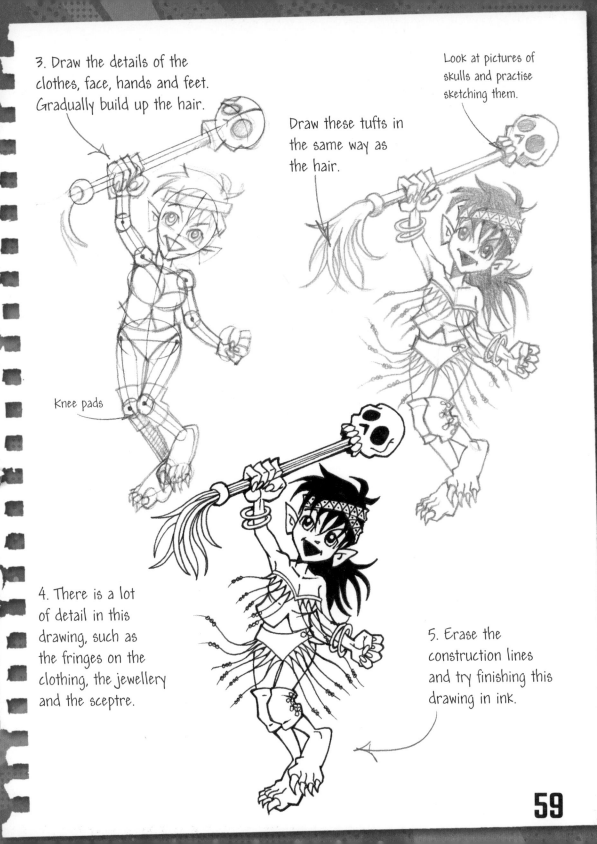

3. Draw the details of the clothes, face, hands and feet. Gradually build up the hair.

Look at pictures of skulls and practise sketching them.

Draw these tufts in the same way as the hair.

Knee pads

4. There is a lot of detail in this drawing, such as the fringes on the clothing, the jewellery and the sceptre.

5. Erase the construction lines and try finishing this drawing in ink.

59

Glossary

Chibi Japanese slang meaning 'small'. In manga art, it is a style that gives characters short bodies, exaggeratedly stubby limbs and big heads.

Construction lines Guidelines used in the early stages of a drawing which are usually erased later.

Cross-hatching A series of criss-crossing lines used to add shade to a drawing.

Elongated When something is exceptionally long and thin.

Gouache Paint made with pigment, water and a glue-like substance.

Hatching A series of parallel lines that are used to add shade to a drawing.

Manga A Japanese word for 'comic' or 'cartoon'; also the style of drawing that is used in Japanese comics.

Parallel When two or more things are placed side by side and have consistently the same distance between them.

Perspective The technique of depicting a three-dimensional object in a two-dimensional picture by making sure that each part of the object is in the correct position

in relation to the others and the position of the viewer.

Proportions The size of each part of something in relation to the whole.

Pupils The tiny holes in the middle of a person's eyes through which light passes, allowing them to see the world.

Sceptre A staff, usually decorated, sometimes carried by a ruler.

Silhouette A drawing that shows only a dark shape, like a shadow, sometimes with a few details left white.

Streamlined When something has a shape that offers little resistance to water or air and can therefore move faster through these substances.

Tone The contrast between light and shade that helps to add depth to a picture.

Vanishing point The place in a perspective drawing where parallel lines appear to meet.

Index